Easy-to-Do
Flower Patterns for Woodcarvers

by MACK SUTTER

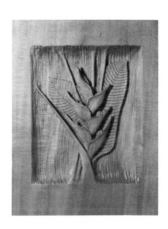

DOVER PUBLICATIONS, INC.

NEW YORK

To my many students through the years,
and particularly those who have gone on to become
excellent carvers and teachers.
I would also like to thank E. J. "Tange" Tangerman,
a close friend of long standing and counselor
in my efforts to improve carving techniques
and to provide books
such as this one to help carvers.

Published in Canada by General Publishing Company, Ltd., 30 Lesmill Road, Don Mills, Toronto, Ontario.
Published in the United Kingdom by Constable and Company, Ltd., 3 The Lanchesters, 162–164 Fulham Palace Road, London W6 9ER.

Easy-to-Do Flower Patterns for Woodcarvers is a new work, first published by Dover Publications, Inc., in 1990.

Manufactured in the United States of America
Dover Publications, Inc., 31 East 2nd Street, Mineola, N.Y. 11501

Library of Congress Cataloging-in-Publication Data

Sutter, Mack.
 Easy-to-do flower patterns for woodcarvers / by Mack Sutter.
 p. cm.
 Includes bibliographical references and index.
 ISBN 0-486-26520-X (pbk.)
 1. Wood-carving. 2. Flowers in art. I. Title.
TT199.7.S87 1990
731.4′62—dc20 90-13959
 CIP

FOREWORD

At the reception desk of the Indiana Dunes National Lakeshore there hangs a walnut relief panel depicting the showy lady's slipper. It is dedicated to my father, who taught me most of what I learned about local botany. He took me to a variety of areas in northern Indiana where special wildflowers still grew in spite of industrial pollution and development. His lore was all self-taught because he had to leave school after the fourth grade, but what I learned from him helped me to get top grades in high-school botany, as well as the Botany Merit Badge in the Boy Scouts. Without his help and that of the author of this book, I doubt that I would ever have carved floral plaques. I have used Mack's designs in my classes for a decade or more, with considerable success, and have never found an alternate source of similar designs or of similar techniques. After all, Mack has designed "thin-blade" tools to make such carving easier, as well as such techniques as stabilizing softer woods so they can accept detail carving without failure.

I own two of Mack's panels, and consider myself singularly blessed. He does not sell his work, so he carves much deeper and with much more detail and undercutting than I do; he isn't concerned about keeping the cost per panel at a marketable amount. And he has taught so long and so well that his drawings and designs are largely self-explanatory. But his designs are not all that easy; I have been witness to breakage of the undercut vine in the wild ginger included here, as well as other "easier" ones in his first book. Many of these designs require very sensitive handling of tools—many small cuts rather than the fewer big ones which Americans with one eye on the clock seem to prefer. Mack complicates the problem, at least in my view, by preferring the softer woods, particularly basswood, while I prefer the harder ones. But his special tools and shellac stabilizing make the likelihood of spoilage much less, and softer woods cut more easily and with less shock.

There is a steady, quiet demand for patterns of floral subjects. Some of this probably dates back into history and the elaborate floral swags and depictions of earlier eras, and some of it is due to the continuing love of people for flowers as home decorations. In any case, the demand for additional and somewhat more complicated floral patterns has led to this second book. This is as it should be; no creative carver is willing to miss the opportunity to add to his skill and knowledge by tackling more difficult projects.

Not all of the patterns here represent added difficulty; some are familiar and well-loved flowers not included in the earlier book, and from additional areas of the United States. Among these are Eastern dogwood, two Southern exotics and a different, deeper rose—which after all has just become the national flower. So there is plenty here for a progressive carver to test his mettle. As I write this, I find myself tempted to get at several. I know I will be challenged to the utmost by some, because I've watched my more-skilled students do them and I recall the challenges of earlier panels of flowers I've done. My best advice is "Try it—you'll like it! And don't forget: Easy does it!"

E. J. TANGERMAN

CONTENTS

INTRODUCTION

Like its predecessor, this book contains 21 full-size patterns of American flowers. They are planned to fit on boards 1 in. or more thick and measuring 1 × 14 to 11 or 12 × 16 in. I customarily carve on basswood, although you can use any wood you desire as long as it will take necessary detail—or can be stabilized to do so (see below).

Copy the desired pattern onto the face of the board, locating it so top and side margins of the cut-out area will be approximately equal—any extra margin should be at the bottom. Select a dry carbon paper so lines will not dissolve and run if moistened with stabilizer fluid (made of alcohol and shellac). Insert the carbon paper between pattern and board, and trace the pattern directly onto the board with a stylus. Check immediately to see if any lines should be strengthened with a pencil.

With a bench knife, skew (chisel with cutting edge at an angle) or firmer (flat chisel sharpened on both sides of the cutting edge), make a vertical cut along the outer outline of the pattern (do not cut into inner details yet). (For curves of less than ½-in. diameter, it may be easier to "set in" (drive down vertically) with a gouge of suitable curvature. (I use the thin-blade gouges in sets 119 and 120 made by Harmen Tools to my design.) Take a ⅛-in. chip all along the outer side of the pattern, as in Figure 1. This protective cut will

Fig. 1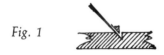

prevent burring and chipping when you set in along the line—meaning that you drive a firmer vertically into the wood. Be careful about this; don't drive in more than ⅛ in. at a time or you may split or bruise the wood. Now "ground out" to the depth of the cut—removing chips to that depth all around the pattern. Set in again and ground out, alternating between these procedures until the desired depth is reached. In most cases, I go at least ½ in. deep. When you approach the desired depth, be careful not to set in too deeply or you will leave a permanent mark along the cut line which will show up in finishing. I like to use a ⅜-in. long-bent gouge for the grounding. When ground-

Fig. 2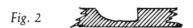

ing is complete (Fig. 2) carry the grounded surface out to the desired dimension on the board and smooth it up; it is usually preferable to end up with ⅜- or

⅝-in. long-bent gouge cuts running with the grain—vertically.

Model the surface with as much detail as you wish, following the pattern carefully (Fig. 3). I feel that

Fig. 3

undercutting will add a great deal to the shadow effects on a panel and make the carving stand out from the background. Modeling has lowered the surface to needed levels, so be certain you have depth enough for undercutting. Start undercutting by cutting a small groove around the pattern edge (Fig. 4). This is again a

Fig. 4

protective cut, and it is usually advisable to stabilize the wood after this cut is made to protect the edges of the design. I do not use a V tool (parting tool) for this V cut; I use a ¼-in. thin-blade firmer as well as for many of the progressive cuts to make this groove the desired depth. This method is slower than using a V chisel, but is much safer, particularly on soft woods. Deep undercutting will be done more easily with a double-bent gouge or a knuckle dog-leg gouge (Fig. 5).

Fig. 5

No two pieces of wood are exactly alike, so stabilizing is usually a wise safeguard, particularly on thinner sections like those suggested in Fig. 5. I have tested a number of solutions and have finally standardized on a 50–50 mixture of clear shellac and denatured alcohol. Soak the surface with this mixture and let it dry before undercutting. If the wood shows a tendency to split, recoat it; some cuts and some pieces may require several coats. Don't worry about the possibly objectionable glaze resulting from repeated applications; you can remove it with a stiff brush and denatured alcohol after completion of the carving.

A general comment may be in order. Make sure the board you select is clear and straight-grained and without checks; the value of a good finished carving is so much more than the cost of the wood that this precaution is justified.

Among the 21 projects that follow, I have in general placed the easier ones first and the more difficult ones later on.

MACK SUTTER

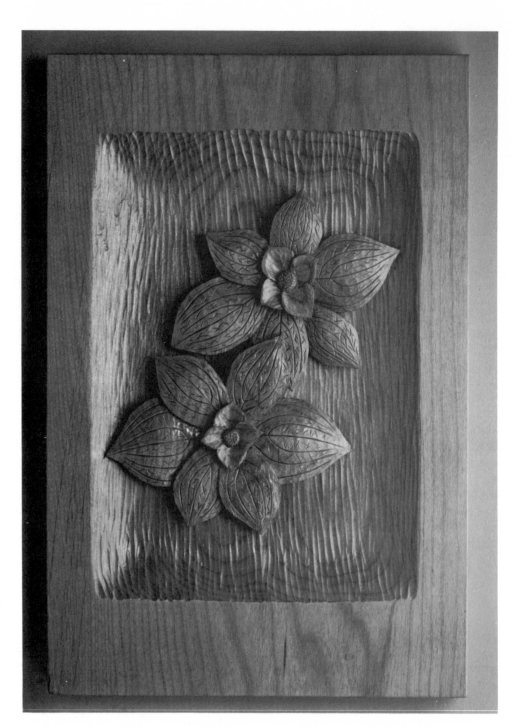

Thanks a Bunchberry

It's the puddingberry in New England.

Only four to eight inches tall, the bunchberry reminds one of the dogwood (to which it is related), even though its four-petal bloom is much smaller and is differently shaped. Its leaves, four to seven, are in a whorl just below the flower, so it almost makes a bouquet by itself. Actually, what looks like petals are four white bracts around the compact central bunch of minute flowers. These flowers bloom in May, but can bloom again in August, and each bunch is only about an inch across. Flowers are followed by brilliant red berries in compact clusters that give the flower its name. The berries are almost tasteless but edible, and the coastal Indians of British Columbia eat them. The whites in New England use them as an ingredient in

plum duff, so they call them puddingberries. The plant does better at altitudes of 1,000 to 4,000 feet, particularly in open woods.

This makes a spectacular carving and a relatively easy one. It is an excellent candidate for undercutting of both leaves and "flowers." Also, the rounded and pointed leaves are strongly marked with V-tooled veins and a sort of cross-hatching. The tiny real flower blossoms, at the core of the four bracts, also can be suggested by a crosshatched marking. In order to get the proper effect, you will want to set in about ½ in. to allow for leaf curvature and undercutting. Be careful to stabilize thoroughly at the pointed leaf tips and in the bracts.

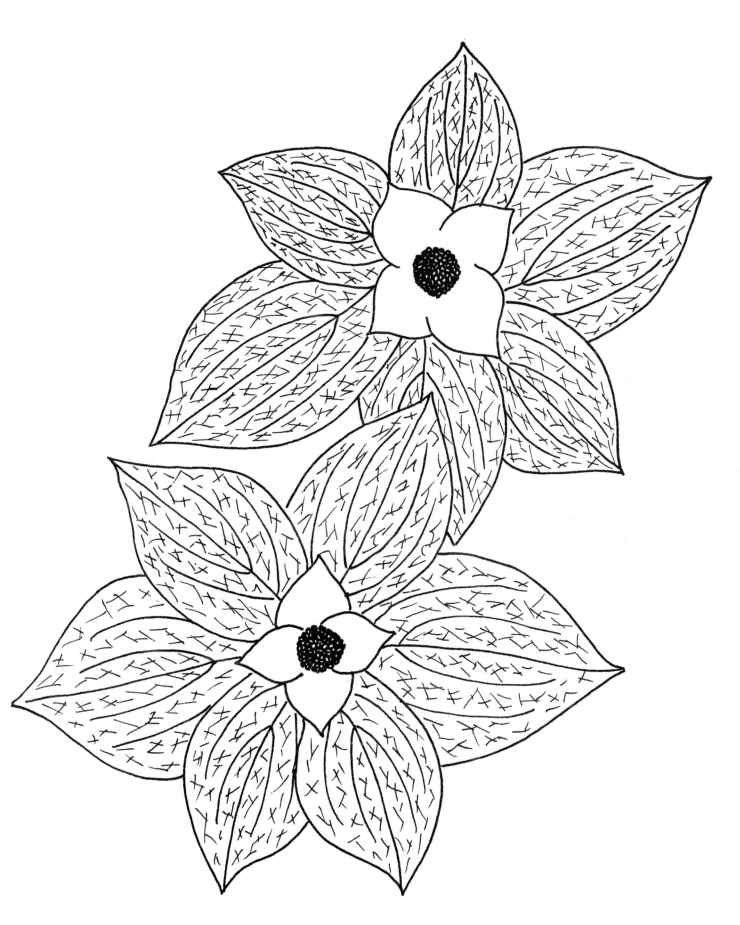

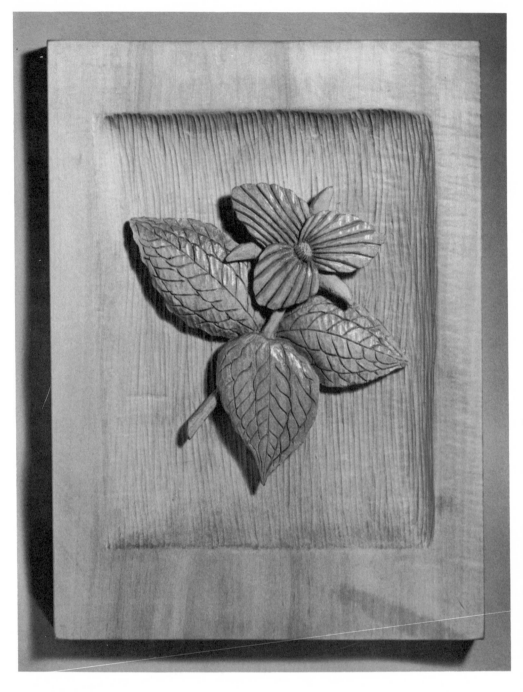

Trillium—an Herbal Plant

An old Indian remedy used by modern doctors.

Wake-robin, trinity flower and wood lily are among the names of this flower, the trillium (*Trillium grandiflorum*). Trillium of course suggests three, and the plant lives up to the name—every part except the stem comes in threes or multiples of three; there are three petals in the flower, three sepals, six stamens, a clearly evident tripartite style to the bloom, and three leaves on each stem below the flower. Usually the blossoms are white, atop a 1- to 1½-ft. stalk, but they can be pink or reddish; there is even a double white. The white, fleshy roots were once used by Indian herb doctors and even now are used by some medical practitioners to treat various conditions. The leaves can be cooked for food.

From a carving standpoint, this is a relatively simple subject. There are only four major elements, a flower and three leaves, so ½-in. setting in will be enough. This allows for three levels of carving, about ¼ in. for the flower at the surface, and ⅛ in. each for the leaves and the stem above the background—except where it rises over the inner edges of two of the leaves. Undercutting is limited to the outer ends of the leaves and flower petals, and the stem, which is only slightly undercut. Note that the leaves curl and can actually bulge at the center above the ¼-in. level, because the two leaves behind the flower are actually behind the stem as well where they meet the flower. The leaves can be veined with a V tool, but the stronger veining of the flower petals should be done with a small veiner (U-shaped gouge).

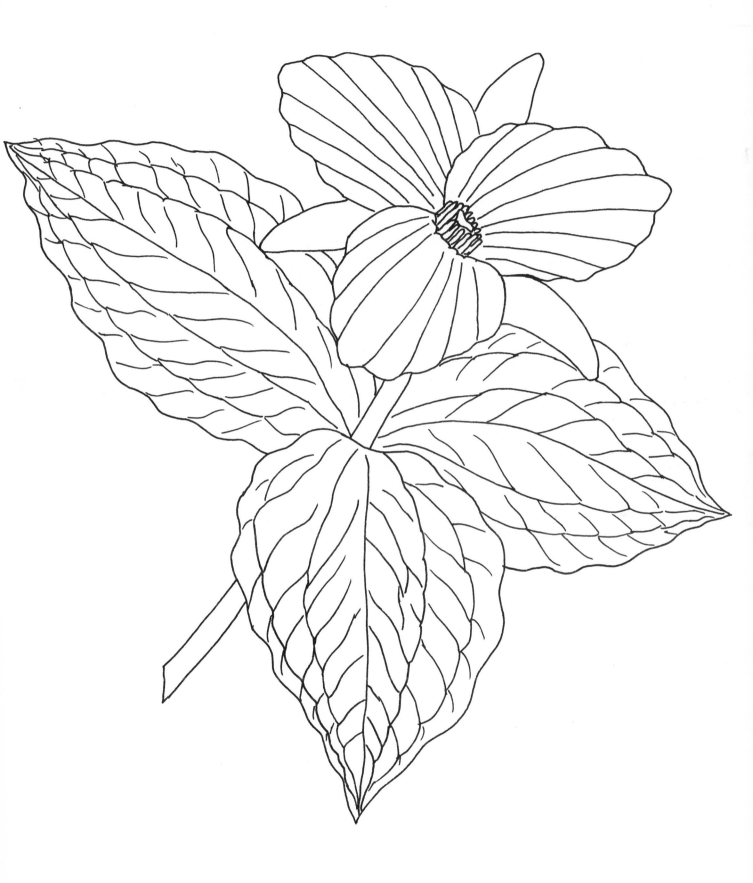

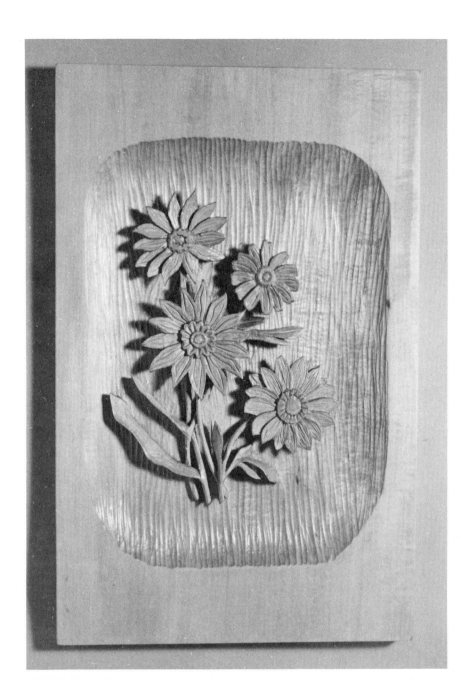

The Colorful Gazania

*"Treasure flower" is a
daisy to carve.*

Theodorus Gaza, a Greek-born scholar of the 15th century, translated into Latin the ancient Greek of *Theoretical Botany* and *History of Plants*, two third-century B.C. works by Theophrastus, pupil of Aristotle. He did the translations while a refugee in Rome from the Turks, who had overrun his homeland. These two were the only books on botany for a couple of centuries thereafter, so a flower genus has been named after him, even if the flower comes from South Africa. The genus now comprises a number of species available as garden seeds. Colors of the daisylike flowers range from yellow, orange, brown and pink to wine-red, ruby, gold and so on. What's more, many of the species combine bold stripes of one color with another. The one I chose, also called "treasure flower" (*Gazania linearis*), is among the bolder additions to gardens. It includes a number of colors in its striped

petals. Other names for commercial variations include acrodenium, rhodanthe and straw flower.

This is a fairly simple flower involving only two levels—the stems and the flowers themselves—so the background can be set in less than ½ in. if you wish. However, leave enough depth over the stems so you can form the overlapping petals and still leave enough for the core of the mature blossoms at bottom and center left. The leaves are simple twists, and the stems should be carved against the background to protect them. There are variations, but the petals tend toward sharp points and lateral striping of contrasting color, which is simulated by grooving with a small V tool or veiner. Stabilizing is advisable, particularly on flower heads and for the stem group at bottom. Carving to separate one stem from another should be a final operation.

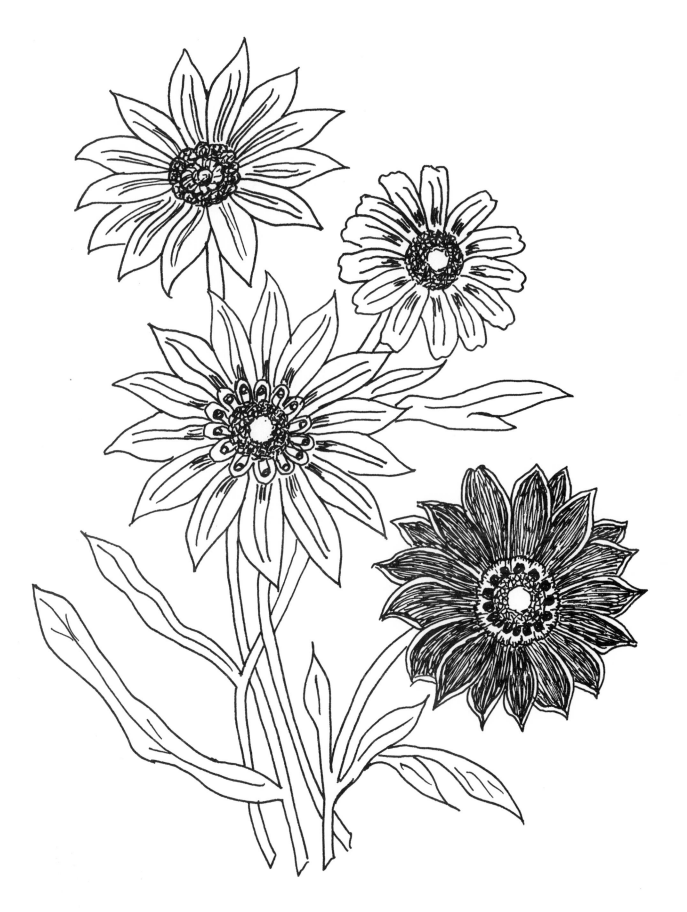

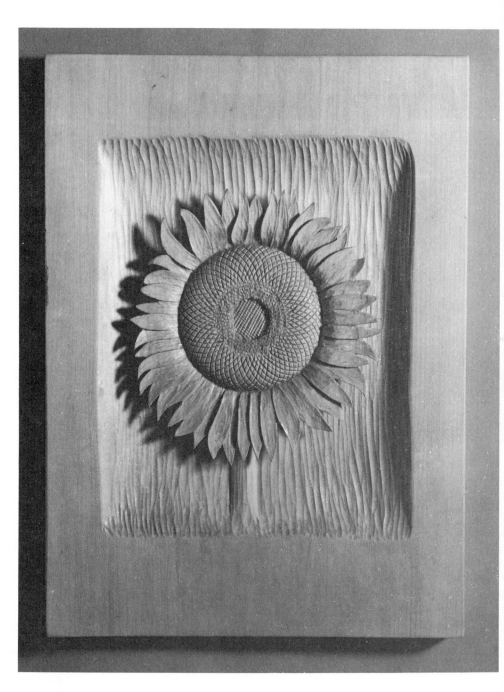

The Pretty— and Useful— Sunflower

It gives us seeds, oil, dye and other products.

The sunflower (*Helianthus annuus*) is a native of South America and was once an emblem of the sun god of the Incas (as was its remote relative the Mexican sunflower). It is an annual and has been grown to unbelievable heights and flower diameters. One grower in 1597 claimed he grew flowers 16 in. across on a stem 14 ft. tall, and another claimed in 1624 that the sunflowers in the Royal Garden of Madrid had grown 24 ft. tall—but that in Italy one had grown to 40 ft.! Obviously some very tall stories. The usual sunflower grows to about the height of a man, with stout stem and a 1-ft. flower.

This plant is grown commercially to get sunflower seeds and sunflower oil, both used in modern cuisines, as well as a butter substitute. The seeds may be pressed into an oil cake fed to cattle and chickens. The flowers are the source of honey (with help from bees,

of course), and a yellow dye and pith from the stems is used in the preparation of microscope slides.

I have sketched here at lower right a reduced cross section of this big single flower, and at left a template for layout of the "seed" ring, which has arcuate crosshatching. There are two circular areas inside it, the middle ring being closely crosshatched at random and the inner one closely crosshatched in a square pattern. The many petals can be a carving problem. It is best to set in ½ in. in a large circle, then stabilize the petal ring and cut the petals individually and carefully, particularly at the sides where you're working across grain. Also do minimal undercutting or you'll be breaking off more points than you can repair. One bit of advice: Keep the working surface clean during this part of the carving, so if you do break off a point, you won't have a fruitless search for it.

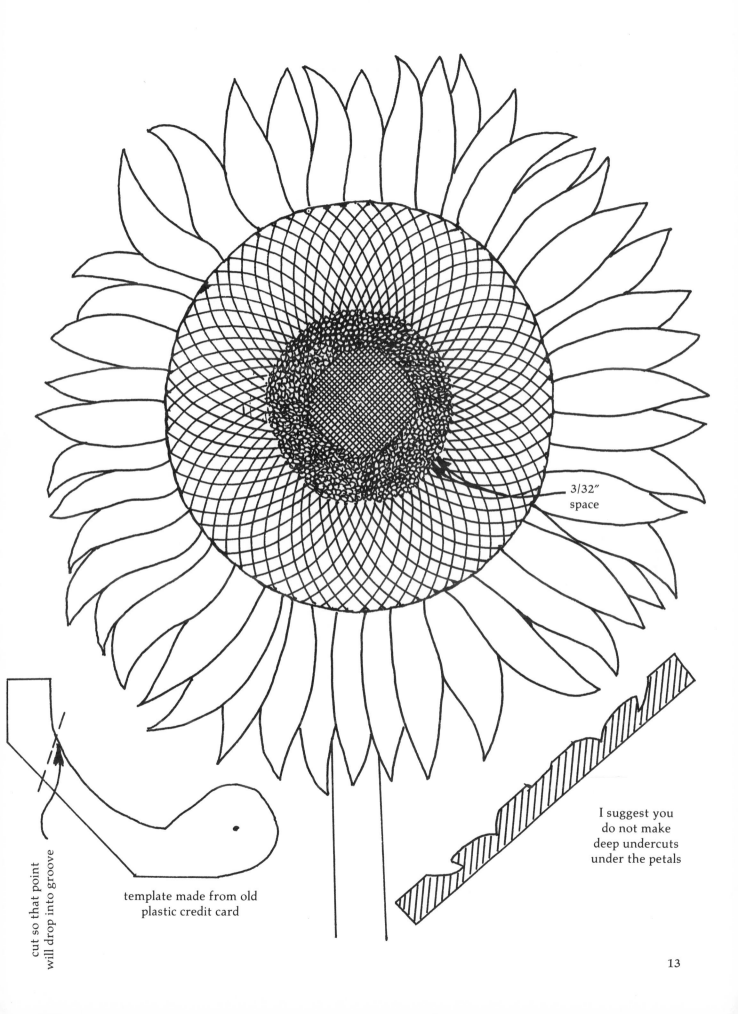

3/32"
space

cut so that point
will drop into groove

template made from old
plastic credit card

I suggest you
do not make
deep undercuts
under the petals

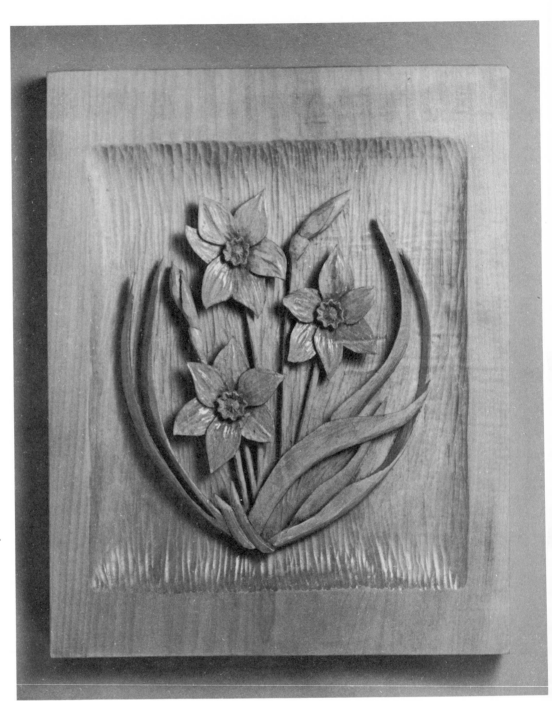

The Daffodil— A Poet's Flower

This narcissus goes way back.

The large narcissus group of flowers includes this yellow daffodil (*Narcissus pseudonarcissus*) distinguished from its also-familiar cousins by the shape and relative length of the corona (cup) at the center. However, the corona poses no problem in this design because the bud is viewed from the side and the flowers from dead front. Wordsworth's famous poem "I Wandered Lonely as a Cloud" was written about this flower because it grows widely in the Lake district of England. It also is now grown in large areas in the United States as well as being sprinkled through lawns and flowerbeds, because it blossoms and dies down before other plants, including grass, do any vigorous growing. It is a familiar Easter flower.

The ground should be set in about ½ in. to give plenty of clearance for the flowers above the stems. It is also advisable to set in around leaf and stem groupings, then cut them to desired height before separating individual elements. Flower petals also have long points and curve at both ends, so cut them wider initially (particularly those across grain) at the tips and thin them down after stabilizing. Note that the center is well formed in a pocket of the flower corona, and that there are V-tool markings on the petals. Undercutting around the flowers should obviously be very carefully done.

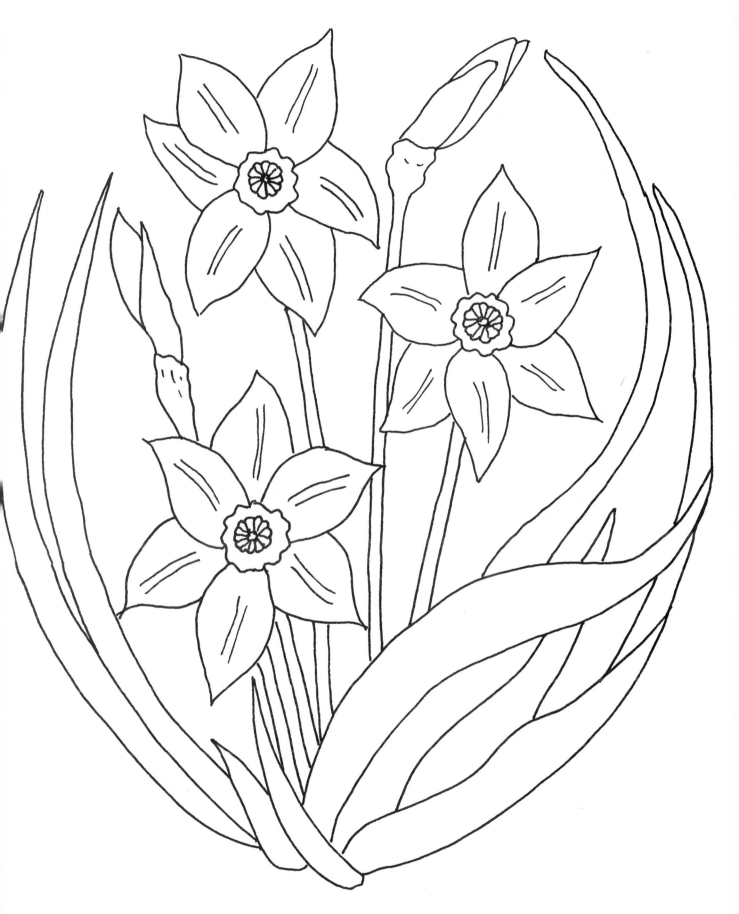

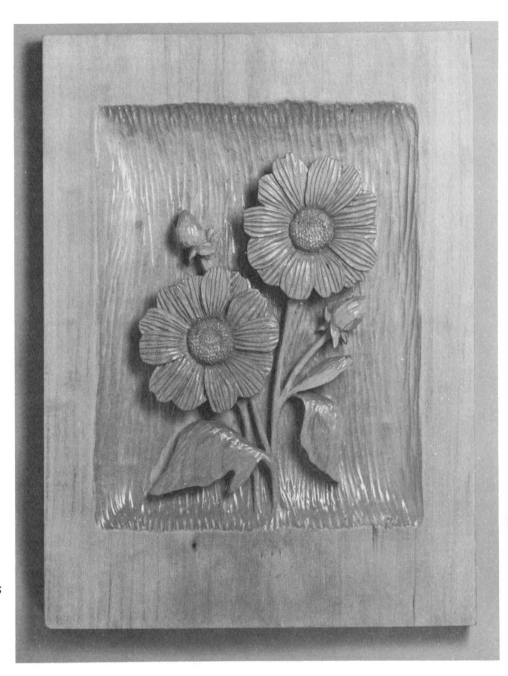

Flower of
the Gods

*The Mexican sunflower is
unlike our familiar one.*

Called the Golden Flower of the Incas as well as Mexican Sunflower, this plant, which resembles our familiar sunflower but is in a separate genus, apparently was known to both the Incas of Peru and the Mayas of Mexico, because both worshipped it as an emblem of the sun. This sunflower (*Tithonia rotundifolia*) can grow to a height of 9 ft. or more, so it is not suitable for small gardens and wet summers. The foliage is also large and coarse, reminiscent of a fig or a mulberry tree. The blossoms, however, are a brilliant vermilion, like dahlias, and can be 3 or 4 in. across.

The two large flowers of this design are relatively simple. Note that some petals overlap others and that the core of the flower is randomly crosshatched after forming with a central depression. However, the little projecting leaflets surrounding the buds and multiple stems must be executed with extra care—the best plan

is to set in outside them, cut them down to the desired level, then separate stems or leaves carefully with constant stabilizing to take care of cut-away areas. The lower left-hand leaf turns on itself so also must be carefully done, and all elements should be undercut to some degree. Note that both leaves and flowers have curved surfaces in both directions.

To simulate the complex structure of flower centers such as this one, I now replace cross-hatching with stamping. I have made punches of several sizes from finishing nails. I drill a hole about 3/16 in. deep in the nail head, then file or grind the outer edge to leave a fairly thin lip. Stabilize the areas before and after stamping. You may want to restamp one or more times to get a desired effect. If you restamp, be very careful to hit the same impressions, or you will get a mashed effect.

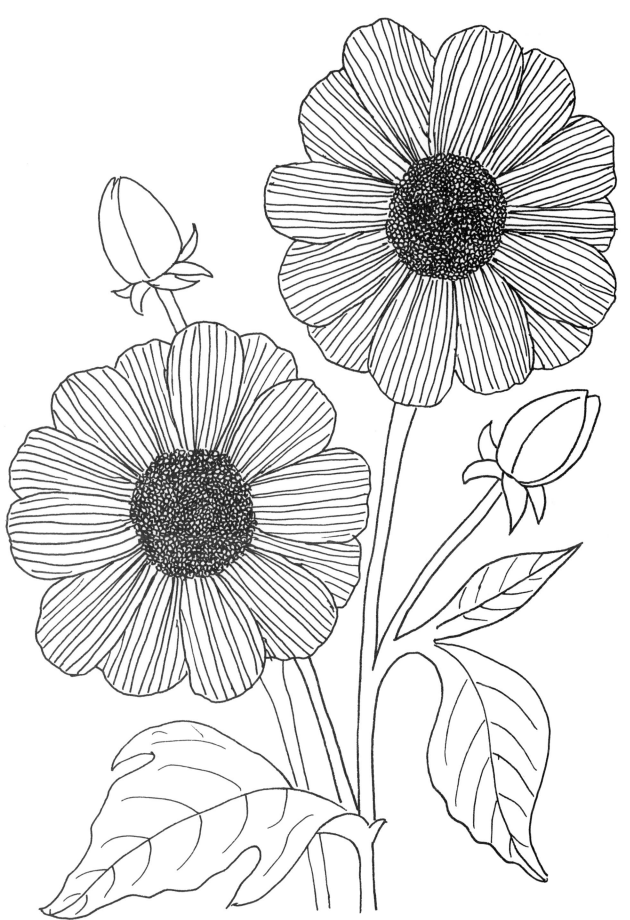

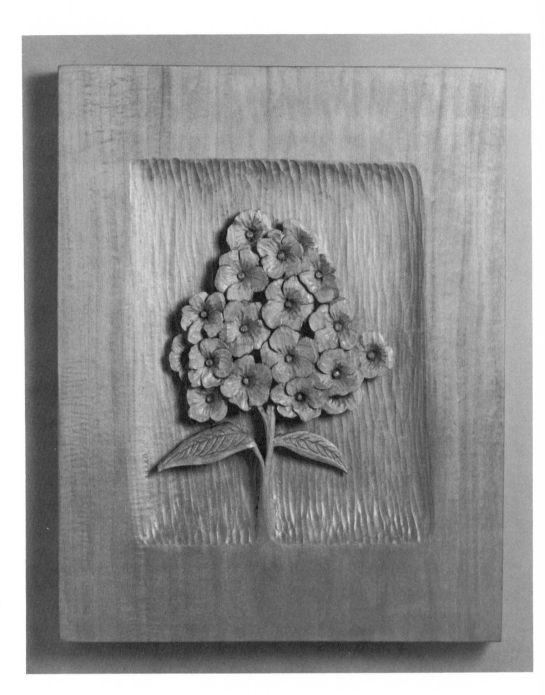

Phlox—
the Flower
Everybody
Knows

*Familiar in gardens
and bouquets, this is
a good project.*

Almost everyone is familiar with the hardy phlox, both the low, creeping spring varieties and the showy taller heads of the ones that bloom in midsummer and autumn. But few people know that the name for the plant is old Greek. It means "flame," applied to this genus because of the brilliantly colored flowers. There are both annual and perennial varieties; the one I have chosen (*Phlox paniculata*) is the showy midsummer variety. Because the botanical name is so easy, it has been applied to every member of the genus, whether it be a little plant growing in rock gardens or one of the taller, more brilliant varieties. Both are used in bouquets. Colors range from white through blue, lavender, pink and magenta (the commonest color). This is a five-petaled flower with a "fuzzy" center, and the flowers are so close that one overlaps the other to make a cluster of bloom.

The overlapping of one petal over an adjacent one, and of one flower head over another, makes this a good carving to try and to show. It looks and is somewhat complicated, but can be worked out in the old-fashioned way—one flower at a time. Set in the background about ½ in., then begin at one edge and work across. The group is fairly flat, but the overlaps make the flowers stand out in a logical cluster, which is accentuated by deep cutting of the spaces between flower heads and undercutting all around the edge. The center of each flower is in a sort of hollow, as can be seen from the photograph, and the "fuzzy" effect is attained by replacing the actual little threads by lines V-cut around the core into the petals. Note that the two leaves have a clear edge, with V-cut veins curving to create that edge effect.

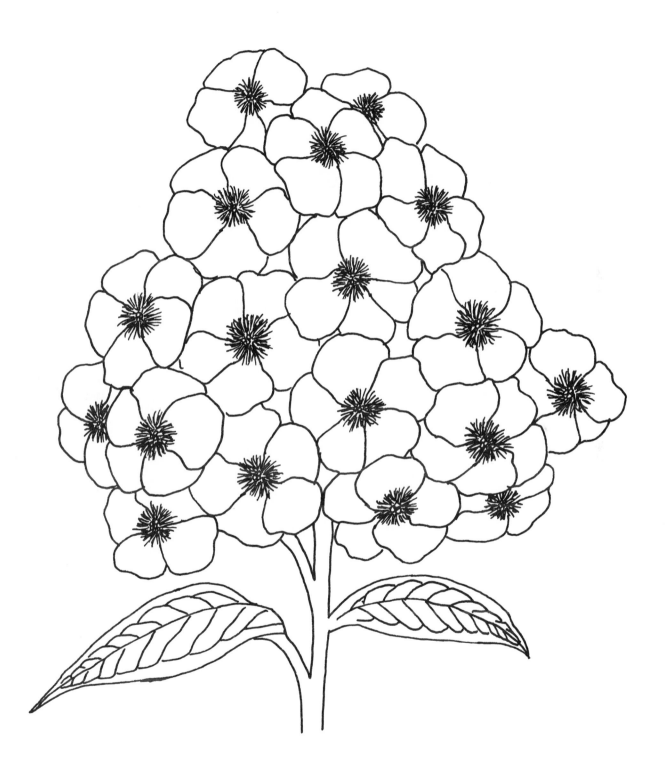

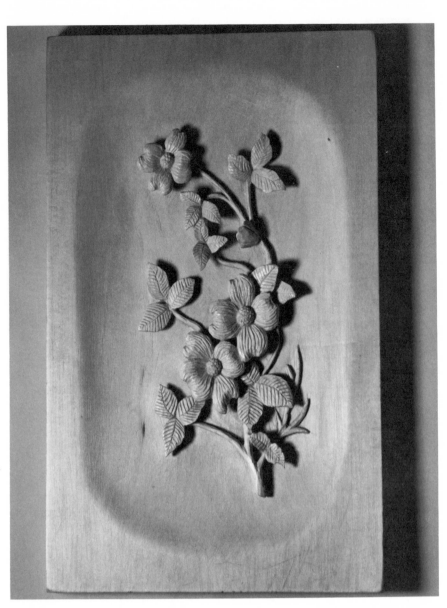

The Dogwood— a Popular Tree

Alternate-leaved and Eastern blossoms.

In my first book, I included a type of Western dogwood with a five-petaled flower of a somewhat different shape than those of dogwoods familiar to residents of the East Coast. A number of readers have asked for an Eastern regional design, so here it is, one that may be used in two ways. With the same branching used for the Western variety, as shown here, and with the distinctive four notched petals with each flower, this becomes the alternate-leaved dogwood (*Cornus alternifolia*), which blooms a little later than the Eastern, or "flowering," dogwood (*Cornus florida*), in which the flowers are fading when the leaves appear. (To shift the design to that of the Eastern variety, simply oppose the leaf stems and branches.) The dogwood has been a very popular tree in the East, and grows wild in many southeastern areas. There are a number of varieties, including the hybrid pink dogwood. Actually, of course, the dogwood "flower" is not a flower at all! The four notched "petals" are really bracts (modified leaves) forming an involucre, with a cluster of many flowers at the center, each consisting of four tiny greenish white petals and numerous minute parts. The tree, incidentally, is not too distantly related to the tupelo, but the wood is much, much harder and denser and very difficult to carve.

When you carve this branch (we're dealing with a tree, not an herb), the branch can go either vertically as pictured or be rotated 90 degrees clockwise to make a horizontal plaque. E. J. Tangerman reports that this is the most popular floral design in his classes, and has been carved to every depth from a very shallow to a quite deep panel. To get the full curvature in the "flower," it is probably advisable to set in the background at least ½ in., so the recess in the floral center can be carved properly and the notches put in the bract tips even when they lie over leaves. Also, this design can stand a good deal of undercutting to improve the shadow effects. (Do not attempt to undercut too much because this will not be visible from the front anyway and it will tend to make the leaves and bracts overly fragile.)

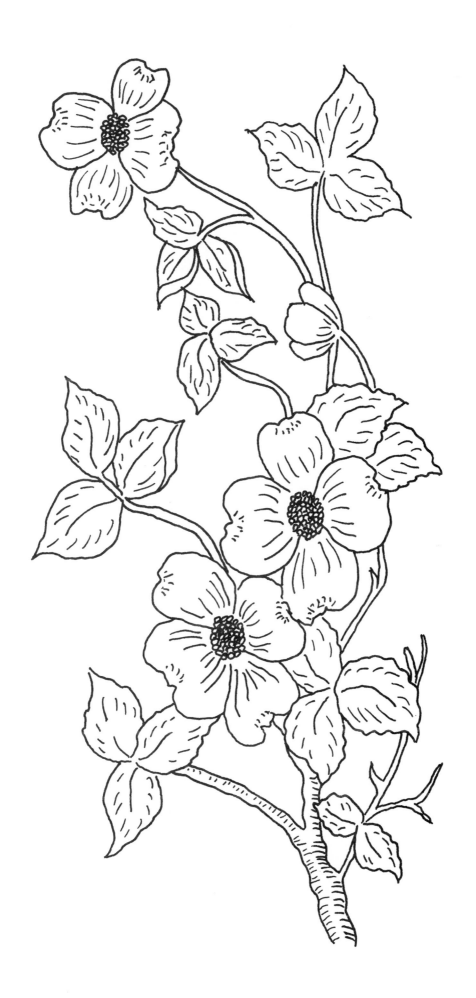

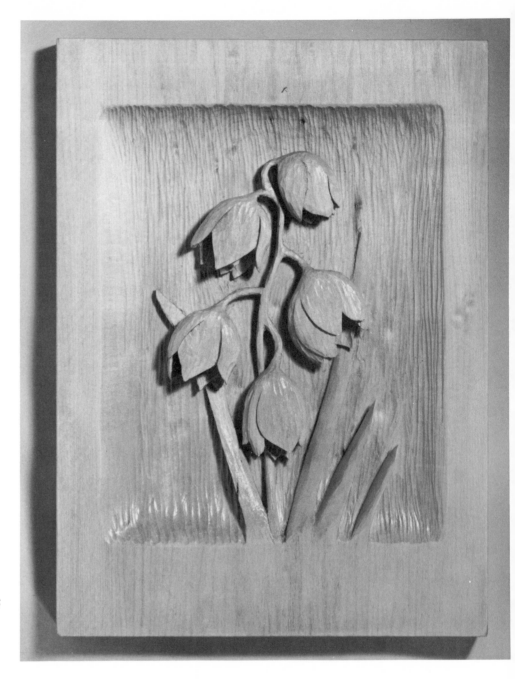

Beware the Spanish Dagger

This desert native makes its own carillon.

Yucca, which gardeners describe as "a striking accent plant," is not for the small garden, because its flower stalk can grow 4 to 6 ft. tall. It is a hardy perennial with long, somewhat stiff lanceolate leaves that are decorative the year round. They stand perhaps 2 ft. tall. Yucca is primarily a native of the Southern United States, and some species grow wild, particularly in desert areas, but you'll find it in gardens and parks somewhat north of its natural range. The swordlike leaf, evergreen, with a sharp spike at the end, has fibrous margins to give this variety (*Yucca gloriosa*) the name "Spanish dagger"; a similar variety is called "Spanish bayonet." In some areas it is called "bear grass." It is well known for its separable sharp tip and fiber. They have given it the name of "Adam's needle" or "Adam's needle and thread" in some areas,

although the prime users of it for such purposes are the Southwestern Indians. It is the state flower of New Mexico. The head of bell-shaped flowers, like a carillon, rises on a sturdy spike in July or August to a height of 4 to 6 ft., well above the leaves, which are shown here at about the same height as the head rather than considerably below it as they normally end up.

The principal carving problem with this design is the branching stem. It should be carved against the ½-in.-deep background and stand up perhaps ⅛ in. This allows about ⅜ in. of depth for curving the flowers into a flattened bell shape with overlapping petals, and for undercutting them a little for further rounding effect. Don't forget that the petals overlap one another.

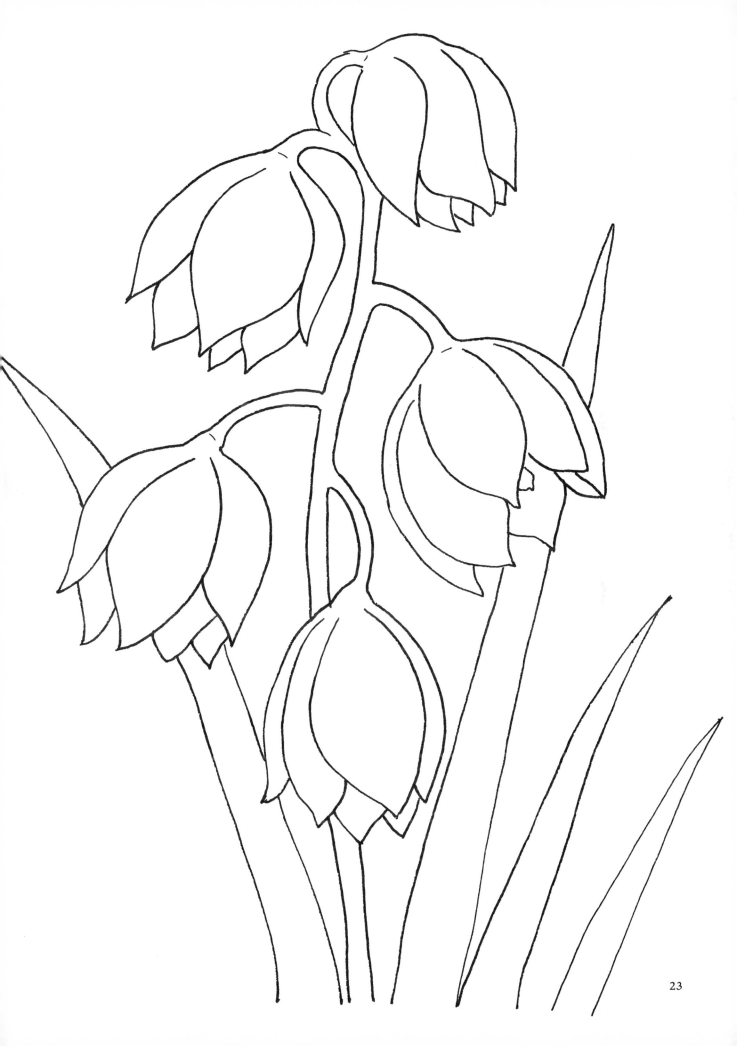

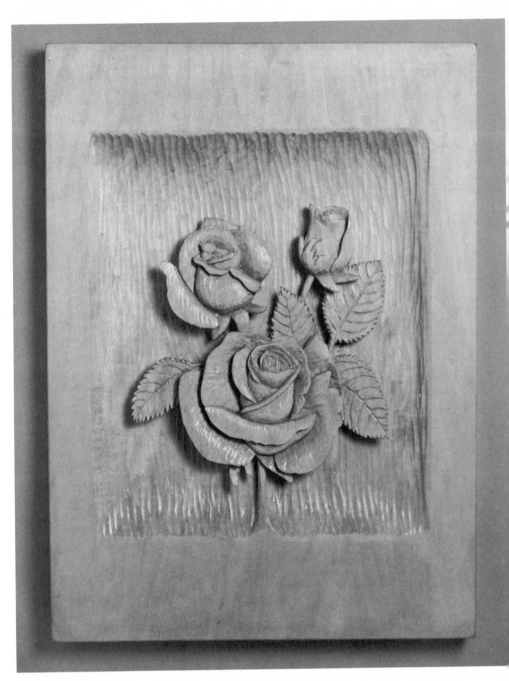

A Rose I Bring You . . .

Regal and romantic—
our most popular flower.

The rose (*Rosa* spp.) was once mostly a simple five-petaled fragrant wayside flower (on about 150 species of shrubs distributed throughout the Northern Hemisphere). Now available in many thousands of multipetaled hybridized versions, it has become the national flower of both England and the United States. This is not surprising; it is at once the most royal and most romantic of blossoms, celebrated in song and story through the ages, particularly as a symbol of love. Notables have sent roses to their beloveds for centuries. Miss America gets a sheaf of roses as the first symbol of her victory; the winning horse in the Kentucky Derby gets a blanket of five hundred.

Just ahead of the Nazi invasion of France in 1940, the Meilland rose house sent cuttings of a new, unnamed, untried rose to nurseries all over the world. Many survived, and the new variety was introduced in California on the day that Berlin fell. It was aptly named the "Peace" rose, and is now our most popular variety. Altogether, the American Rose Society has registered over 12,000 cultivated varieties, recognized worldwide. In America alone, roses are purchased every year by the hundreds of millions.

The rose, incidentally, is related to apples, cherries, raspberries and other fruits. We tend to forget that the wild rose produces its own fruits—"hips"—that help make jellies, jams and vitamin C.

This panel involves more undercutting than the one in my first book. It also adds a partially open bloom. The ground should be set in about ¾ in. at least, to allow for petal shaping.

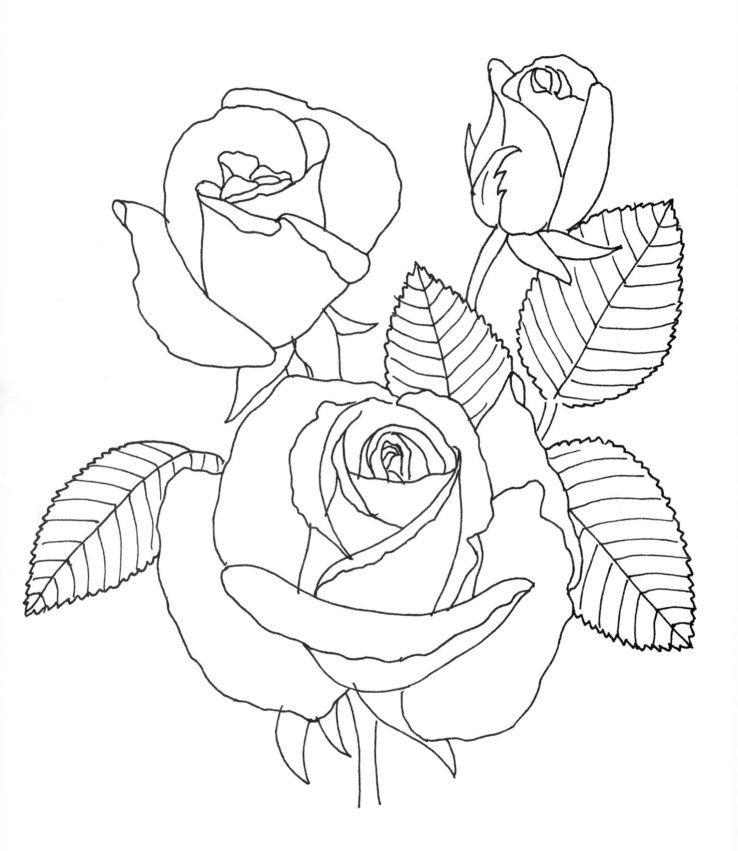

A Lobster Claw— Botanically Speaking

The Heliconia has gotten a northern nickname.

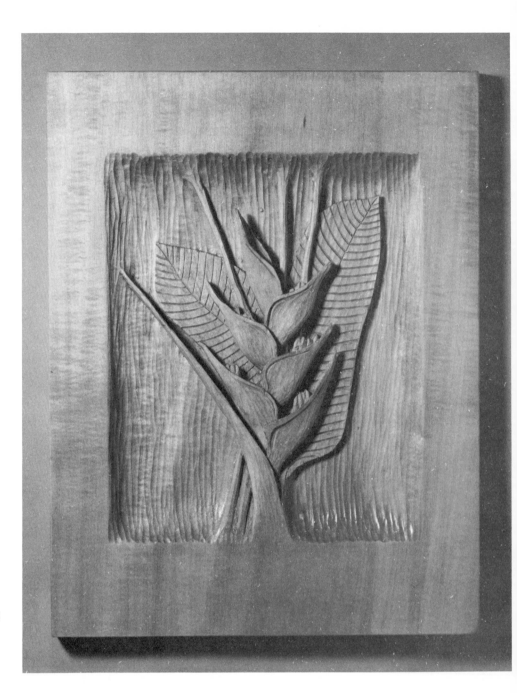

Known familiarly in florist shops as the lobster claw, the heliconia (*Heliconia wagnerana* and other spp.) is widely used in floral arrangements because of its distinctive shape and soft coloring. It is a native of tropical America, and is delicately tinted. Each "claw" is a pinkish to red spathe (type of bract) edged with yellow and green (variations occur, depending on the species). The flowers themselves vary in color—usually white or yellow—and conspicuousness, again depending on species. The leaves are quite large and broad. It is a long-lasting and spectacular flower in its quiet sort of way.

Obviously, a carving of this flower that is untinted must emphasize the shape. Note that each spathe flares along its edge, and that heart elements (the flower) can just be seen peeking over the center edges of mature spathes. Again, a reasonable amount of depth makes carving easier. The background can well be a bit over ½ in. deep to allow for the multiple layers of flower and stems over the leaf. (To estimate the depth of setting in for a design like this, count the number of "layers" and make due allowances for each. In this case, a minimum would be ½ in., allowing ¼ in. for the spathe-and-flower, ⅛ in. more for the stems behind it, and ⅛ in. for the leaf.) While leaf veins are usually a marked line on the upper surface and rounded on the under side, the effect can be simulated in this carving by incising the veins with a V tool. I used a background of relatively narrow vertical stripes, which is easy to carve because it runs with the grain, thus avoiding roughness in soft woods.

26

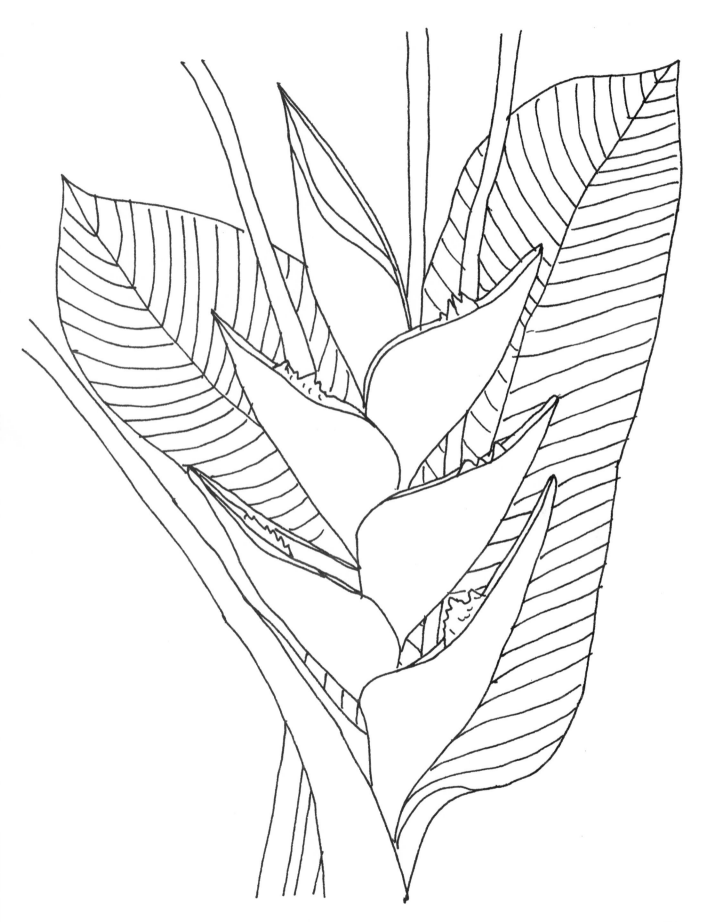

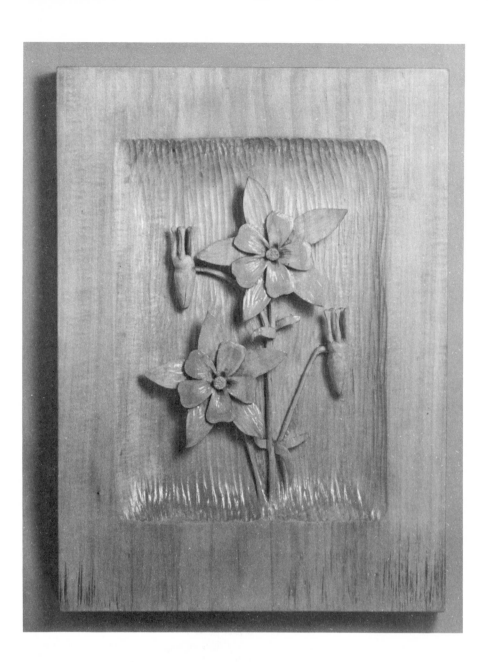

The Blue Columbine Grows Wild

Colorado's state flower forms in sunny colonies.

Aquilegias or columbines have long been favorites of British flower fanciers and have been cultivated in England for centuries. They were mentioned by both Chaucer and Shakespeare and were formerly used to garnish food and as a medicine. The latter use was discontinued, however, long, long ago, when there were deaths from overdose. The blue columbine that I have selected for a pattern (*Aquilegia caerulea*) is the state flower of Colorado; it can also have creamy white flowers rather than the lavender-blue of the state flower. This flower will grow wild in the sun, seeding itself and developing large colonies.

As a carving project, this design is medium difficult because of the long nectar tubes (spurs) extending from the back of the flower and the three small leaves in stem joints. The bloom is a double layer with five pointed sepals forming a star behind five lobed petals. The small center of the flower is a circular button, and its texture is suggested by fine cross-hatching. The marking on the petals can also be suggested by parallel fine veiner or V-tool lines leading to the core "button." If you wish, the area of these lines can be tinted slightly to accentuate the center and to strengthen the look of the flower as well.

Set in ½ in. or slightly more, but leave the buds and stems securely anchored to the background except where it is essential to carve the tiny triple-leaf groups. Also, it is advisable to set in the nectar-tube area as a single clump and separate the tubes later when undercutting. It is possible to undercut portions of the tiny leaves and the central nectar tubes on the buds if they are thoroughly stabilized and treated very gently. Note also that the stem to the upper bud comes from under the flower, so very careful work is essential around it. The safest approach to carving the stem branchings is to leave them solid until you cut back to the desired stem level, then to clear and shape the stem down the much shorter distance to the background.

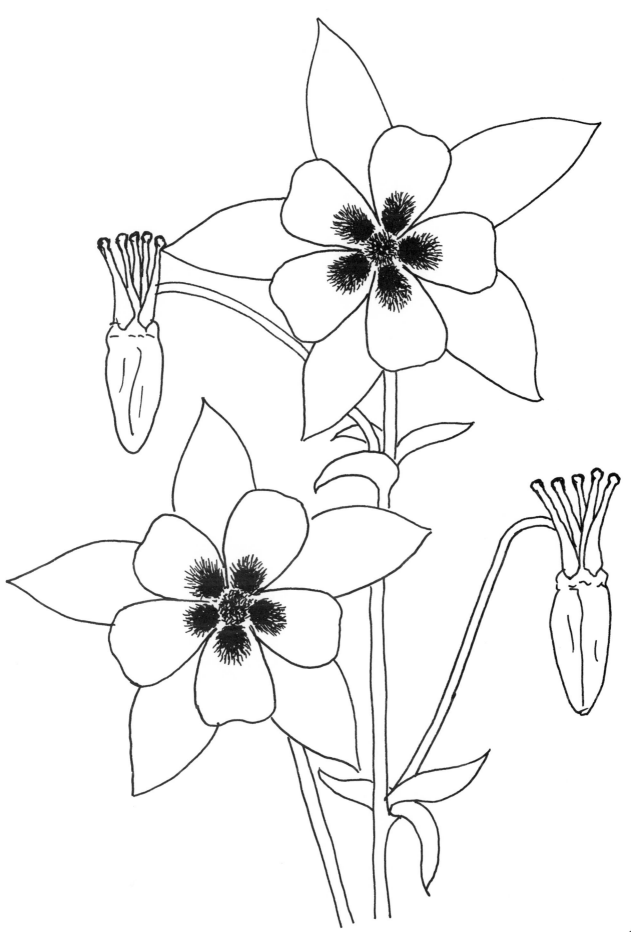

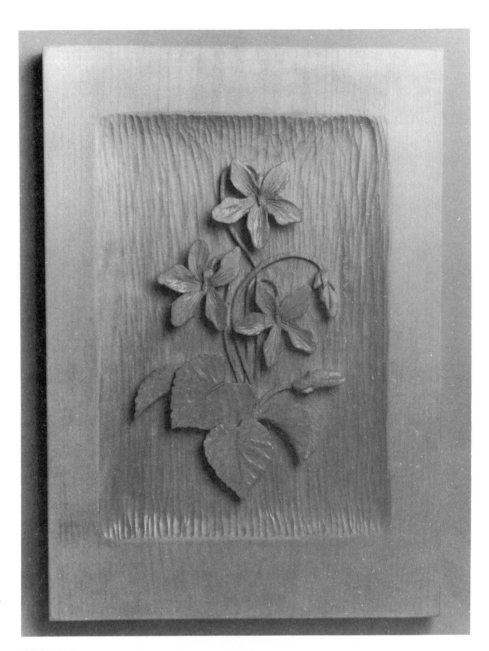

The Modest, Fragrant Violet?

Wild varieties may be neither, but poets disagree.

Violets have long symbolized modesty and fragrance in poetry, but many varieties are bold and nonfragrant. Also, the usual "blue" violet is more nearly purple. My pattern is for *Viola adunca*, the Western "blue" (or "dog") violet, but it is quite similar in shape to most of the Eastern varieties, like the bird-foot, common blue, sweet white and downy yellow. Of them all, it is not a blue violet but the Western sweet white (*V. macloskeyi*) that is the most fragrant in the wild. (Some domesticated species have been hybridized for fragrance.) All of these violets have five petals, and most have appropriately heart-shaped leaves coming from the base, but some have lance-shaped leaves or leaves branching from the stems, so if you want to adapt this pattern to a local variety, be aware of leaf shape and position. Also, many violets do not have indented, lobed petals like this one: they are simply long and rounded at the ends. Leaves on this variety are wavy-edged and brown-dotted and stalks are short. There is bearding in the flower throat and the pistil is exposed.

The major problem in carving this design is the intertwined stems, which are also quite thin. It is advisable when setting in to leave them wider so they won't split off surface pieces so readily, and to lower them to the desired level before thinning. The central group of four stems should of course be left as a single shape until final carving. Again the setting in should be ½ in. or more to allow room to take care of curled leaves, flared petals and the overlay of petals over stems. The stems should be not more than ⅛ in. over the background, and they are too narrow to be undercut safely. However, the petal ends and leaves can be undercut to create good shadow effects and a feeling of lightness.

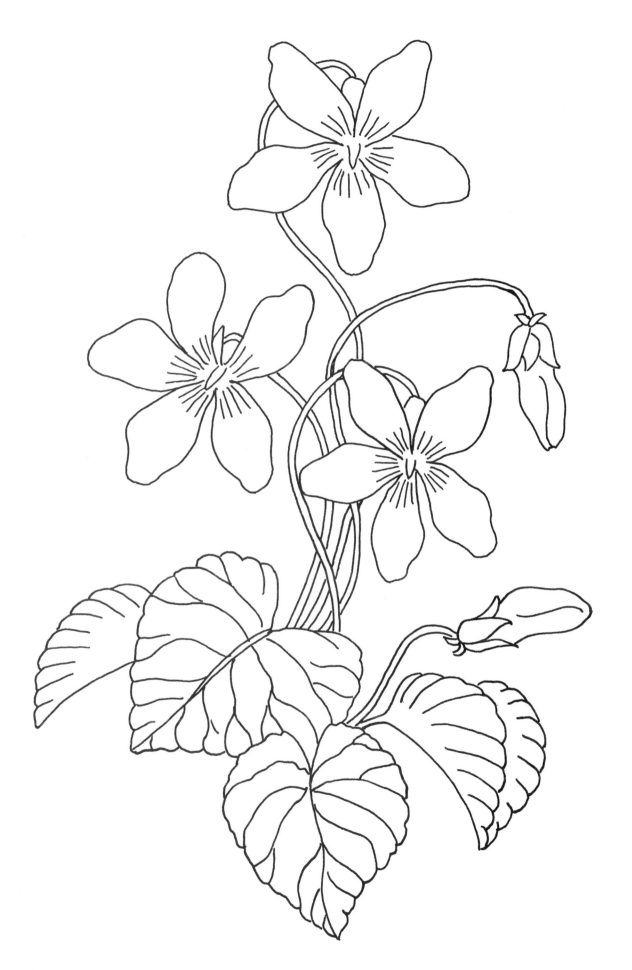

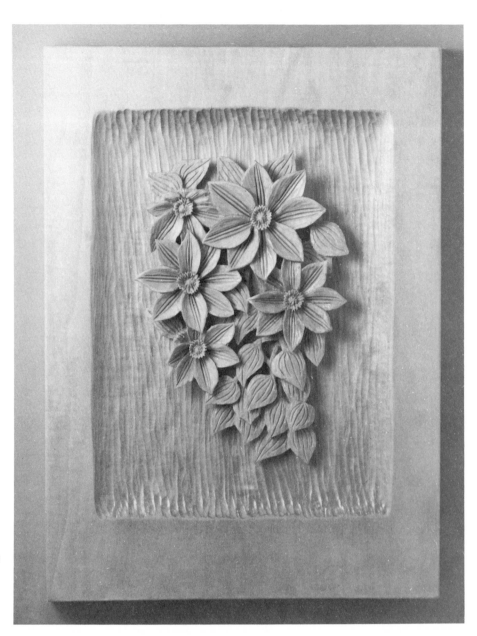

Clematis—
Queen of
the Climbers

This popular vine has many
flowers and many uses.

Long-lived, easy to train and with a long blooming period, the clematis is probably our most popular cultivated vine. There are over 200 species, with many of the cultivated ones originating in places like China and the Himalayas. Also, they come in colors like yellow, orange, purple, mauve, violet, pink, red and white, with bloom size ranging from almost tiny to 3 or 4 in. across (even 6 in. in hybrids). Thus it has become a standard for hiding sheds and stumps, for climbing walls, arbors and trellises. It can readily be intertwined with climbing roses. One variety (*Clematis vitalba*), known as traveler's joy, grows wild on chalky soils in southern England and is called by local names such as old man's beard, old man's woozard, grandfather's whiskers, hedge feathers and snow in harvest because the white long-lasting bloom is succeeded by round, white, silky seedheads that last for months. Workmen cut lengths of the stem and smoke them like cigarettes, giving rise to names like smoking cane and

boys' bacca. It has been hybridized since 1862 in England, when a large purple-blue flower was developed. This is the ancestor of the many hybrid varieties today, particularly those with large blooms. Blooms can be single or double.

I selected *C. henryi* for my pattern, because it has large blooms closely spaced in groups. Note the multiple veining of the larger petals (actually sepals; clematis has no true petals) and the feathery character of the central element. The latter requires very careful work if it is to look as light as it is. Because one flower overlaps another and all overlap leaves, it is necessary to set in about ½ in. to give yourself adequate working space. This also permits undercutting, which will give the composition a good third dimension. As with any pointed section, the points of these petals must be carved with extreme care, assisted by stabilizing in the softer woods.

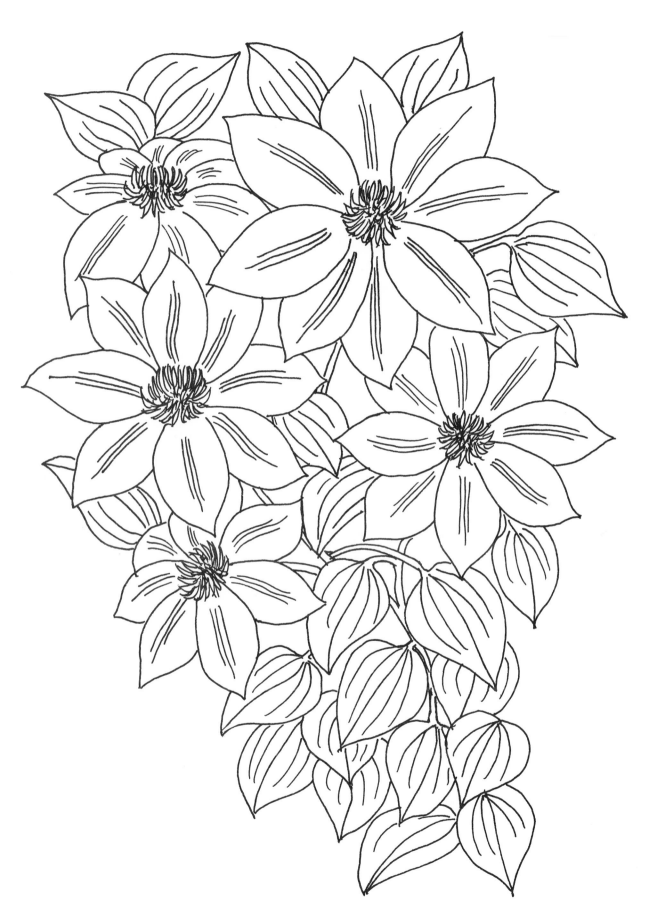

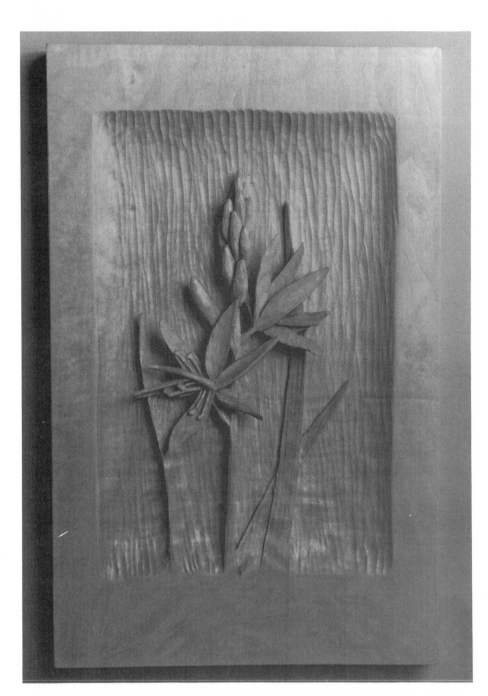

The Camas Caused a War

*It was food for
Northwestern Indians
until the white man came.*

The Bannock Indians' 1878 war against the white man was fought mainly for one offense: plowing up their camas fields in Idaho. Camas (*Camassia quamash*) was the most important and best-known food plant of the Bannock, Nez Percé and other Northwestern American Indians; most Indians (and later white explorers) relied upon it when other foods failed. So a great many legends and stories grew up about it and its flowers and root. The "root" is actually a deep-seated bulb which is roasted. The leaves are narrow and tall, coming up from the base. The flower is six-petaled and fruit three-lobed. Flowers can be blue or white and number as many as ten to thirty per plant, so a field of them is quite a sight from April to June—and so important to the Indians that it was held tribally.

The plant could sometimes cover many square miles. The Nez Percé still eat it and go through an elaborate ritual of ground-baking supervised by the old women of the tribe—but now they add sugar and cream.

The camas is an interesting floral carving because of its long petals, pistil and six stamens, all requiring careful carving. Obviously the stamens and pistil must be laid against adjacent petals (which may curl at the ends). This pattern has three distinct levels: the leaves in the back, the central seeded stem and the projecting flower, so it needs ½ in. of setting in. Again, it is advisable to leave narrow sections, particularly across grain, wider until final shaping, and to be certain that narrow sections are thoroughly stabilized all through the shaping.

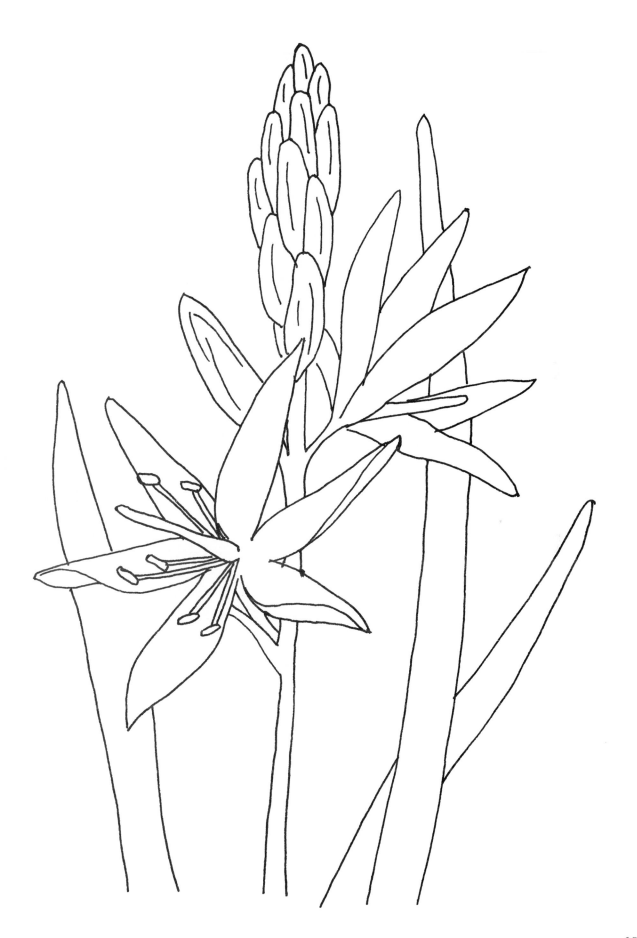

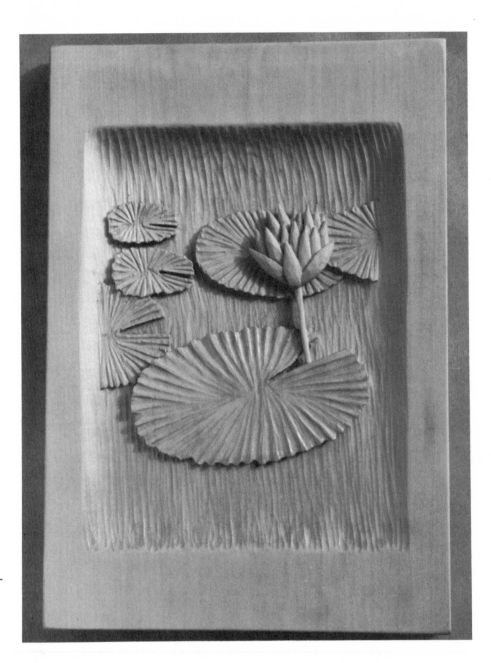

The Elegant
Water Lily

*Loveliest of water plants—
and widely known.*

The water lily and the lotus have come down through history as the most beautiful of water plants. Midwesterners and Easterners are familiar with the "fragrant" or "white" water lily (*Nymphaea odorata*), which has numerous white, waxy petals and floats on the water surface. The leaves can be gigantic—up to 10 in. across. These water lilies are also quite difficult to carve because of the many shaped petals. They are the hardy variety suited to northern climes. More widely scattered are the tropical varieties, which bear their blooms on a stem above the water and resemble the lotus. Also, they can be in shades of red, pink, white, blue, purple and yellow, and they are a favorite for shallow home pools, and usually planted in tubs or crates. This pattern is for the tropical kind of flower standing up on its stem and arising through the cleft in the broad floating leaf. (Some such leaves are curled up at the edges and can be 2 ft. across, so they will sustain the weight of a man momentarily.) Like our native water lilies, they are members of the genus *Nymphaea*.

Here the primary carving problem is one of perspective. The broad leaves must appear to be floating on the surface of the water, and the blossom must stand above the surface. Also, the blossom is multipetaled and must appear to be supported by the stem. The leaves are ribbed and quite broad, so some depth of carving should be allowed to get proper perspective effect. This suggests setting in at least ½ in. and using some of that depth to "tilt" the leaves against the background and to make the flower stand out from the leaf behind it—which requires undercutting. This one is a nice study in perspective; let your eye guide you in obtaining proper planes and "feel"; no mechanical measurement will do it.

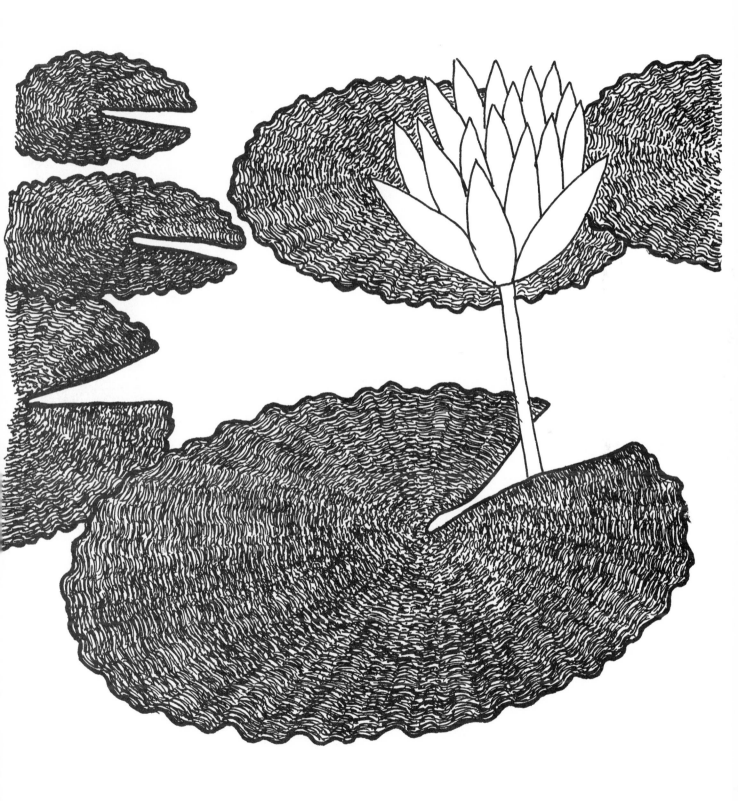

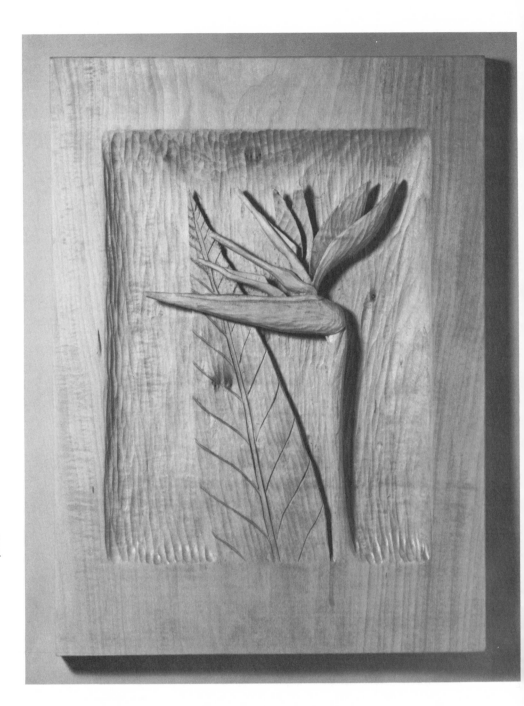

Catch a Bird of Paradise

An exotic emigrant from South Africa.

The bird of paradise (*Strelitzia reginae*) is a familiar large-bouquet flower, related to the banana, and grows in Florida and Central America, although it is a native of South Africa. It has even become a hothouse plant in northern climates because of its striking colors. The tall stalk looks like a bird's green neck, and it is topped by a bluish head and sharp beak with a crest of brilliant orange. The "head and beak" are actually a bract, from which the three-sepaled flowers (each also with three less-conspicuous petals) lift at a rate of one a day until there may be as many as six. (There is a white-flowered type as well [*S. nicolai*], with reddish-brown bracts.) The leaf resembles that of the banana and may be 1½ ft. long.

Because the bract must stand out ahead of the leaf, it is advisable to set in the background about ¾ in. This permits the leaf to show slight curl and to stand out at the edges, and the bract and flower stalk can be almost in-the-round, thus permitting proper carving of the delicate flowers. Leave the flower ends solid, of course, while setting in, and shape them as a final operation. Flower petals and sepals should give the effect of thinness by undercutting, but don't make them too realistic back from the edge—don't hollow the inside to full depth, and don't undercut so far that the flowers are separated from the background. The stalk should bleed into the "frame" at the bottom, and I prefer to have the margins of the trenching somewhat indistinct and the background slightly roughened. Shellacking the flower area while carving to stabilize the wood is important—unless you carve in a dense wood.

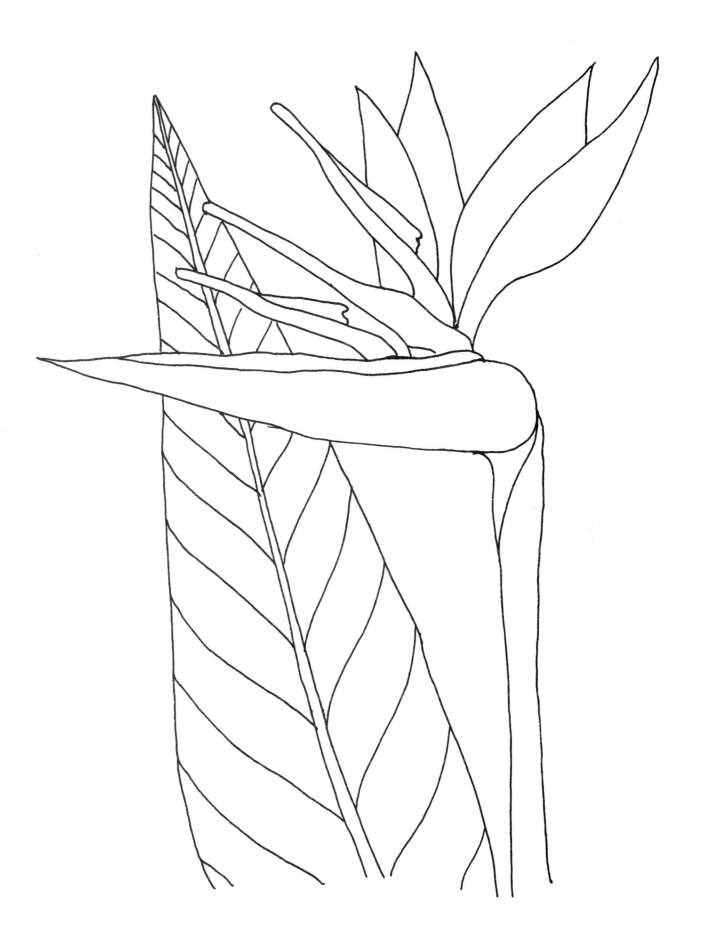

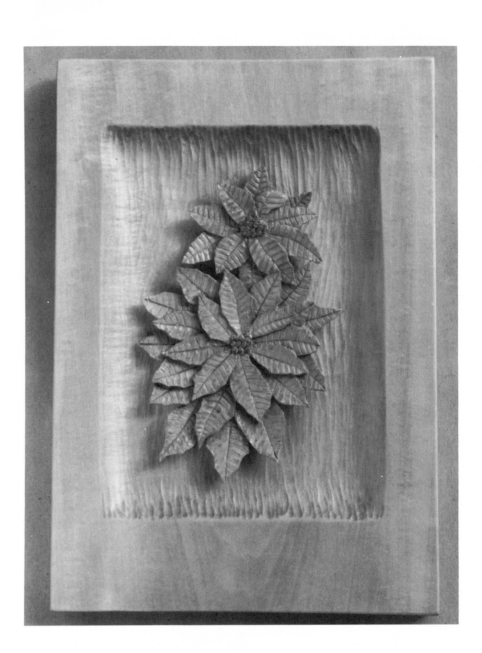

Poinsettia—
the Christmas
Flower

*In Mexico it is
"flor de Noche Buena."*

Joel R. Poinsett, America's first minister to Mexico (1825–1829), was asked to leave because he nosed too far into Mexican politics. He brought back to South Carolina cuttings of a roadside weed that was thought to belong to a new genus, so it was named after him— *Poinsettia*. The plant was later discovered to be another member of the genus *Euphorbia*, so the poinsettia is now *E. pulcherrima*, but its common name has stuck.

In Mexico, it is still "flor de Noche Buena"—flower of Christmas Eve—and a legend explains the name: a little peasant girl, Pepita, was too poor to have a Christmas gift for the Christ Child. When a cousin explained that no gift was too humble, she gathered a bunch of the beautiful plants as her gift, and felt blessed.

An eleven-year-old Hollywood lad, Paul Ecke, having heard the story and seen the plant in 1906, convinced his German-immigrant father Albert to try some cuttings on his commercial farm. They took well in Southern California, so Paul added the blooms to the milk cans of fresh flowers he sold on Sunset

Boulevard. Fourteen years later, he had developed a variety that could be grown successfully indoors, and shortly thereafter he traveled coast to coast selling his idea of the Christmas symbol. He was vastly successful, and the Paul Ecke Poinsettia Ranch in Encinitas, Cal., now sells to more than 5,000 floral customers all over the world. The plant is sold as cuttings, blooming potted plants and blossoms, particularly at Christmas. We even now have growing miniature poinsettias (Ecke's latest product) 3 in. tall, as well as white ones that contrast with the brilliant red-orange of the familiar plant. The flowers are actually the little yellow clusters in the middle of each circle of bracts— what we call the flower is actually a ring of bracts, or modified leaves.

This piece is a bit complicated to carve because of the many leaf points, and requires careful stabilization at the outer leaf ends that are across grain. It is best to leave leaf tips slightly bulbous initially and cut them to shape later. Veins and details of the actual flower clusters are cut with a V tool.

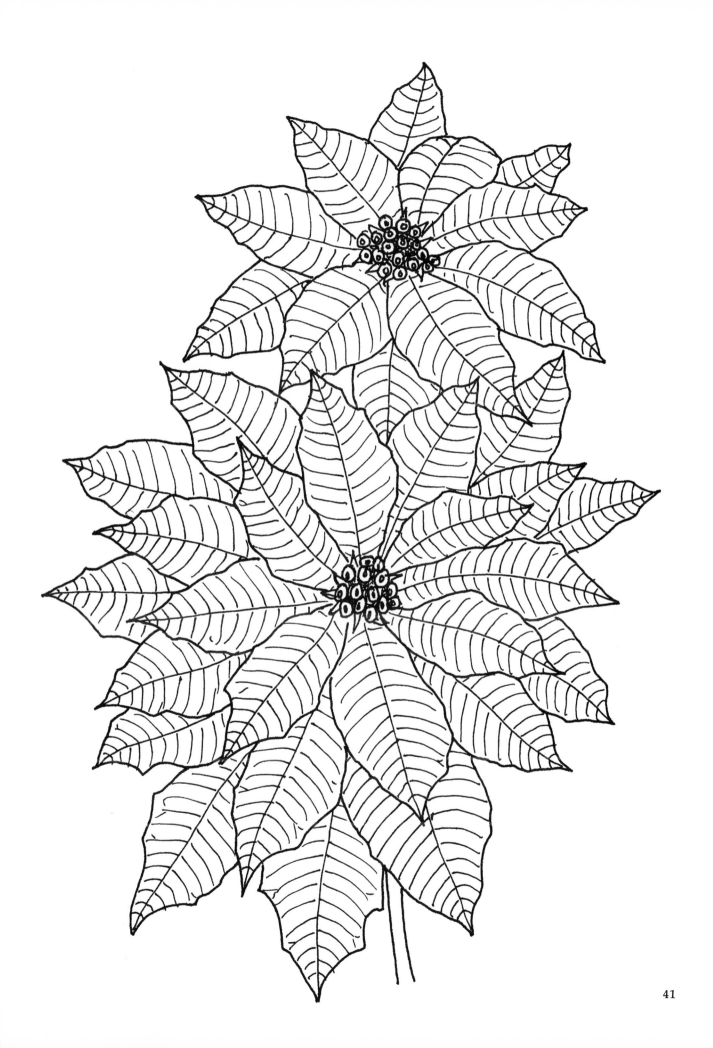

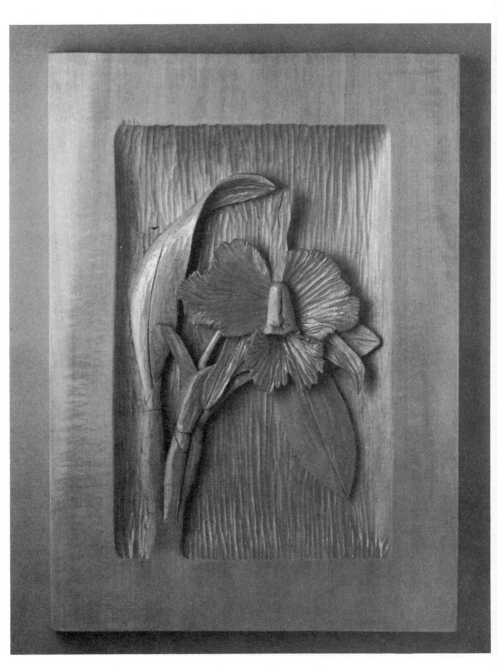

The Now-Familiar Easter Orchid

This is the best-known member of its family.

To most people, the word "orchid" brings to mind one species: *Cattleya mossiae*, the Easter orchid, with its flamboyant big rose-lilac flower. It is now widely grown for the florist trade as well as by hobbyists. The name *Cattleya* comes from William Cattley, a North Londoner of 170 years ago who was very interested in the genus. His collection was passed on at his death in 1832 to a company that still exists in England. There are more than sixty species in this group, all from tropical America and all epiphytes (an epiphyte is a plant that depends upon another plant or other object for support but gets its nourishment from the moisture in the air and the organic matter that naturally accumulates around it). Most *Cattleyas* originally live on trees in moist tropical mountain forests. Nowadays, they are successfully cultivated in composts in greenhouses and even, with adequate care, as houseplants.

A carving of a flower like this is a challenge because of the crinkly petals and the necessity of attaining an apparent depth much greater than the wood provides—a problem in perspective. This is particularly apparent in the carving of the central "lip," which would actually project an inch or two from the rest of the flower. Also, the petals are crinkly along the edges, and the stems bear leaves with a compound curve. Thus it is advisable to set in as much as ¾ in. to give necessary clearance for the flower in front of leaves that are themselves curled, with the lip of the flower projecting still farther forward. This requires crisp carving and careful delineation of edges, plus some undercutting where it is possible. In a carving like this, it is essential to let your eye lead you to proper proportion.

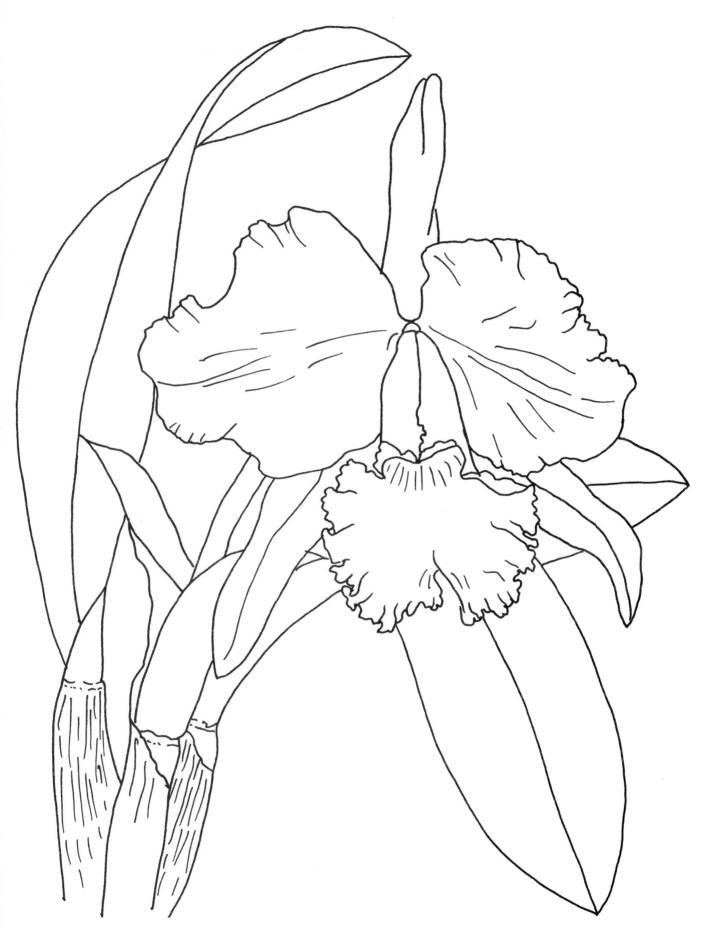

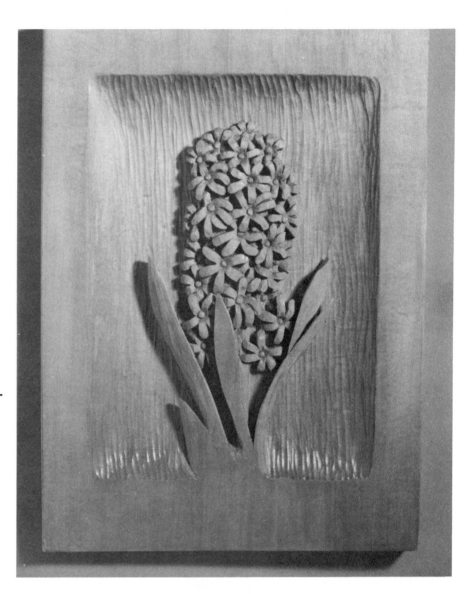

The Hyacinth— a Familiar Friend

Multiple flowers make this house and garden perennial a challenge.

Familiar in many spring gardens and often planted as a colorful front to shrubbery, the hyacinth (*Hyacinthus orientalis*) is a native of the warm shores of the Mediterranean, but the bulbs are now largely a Dutch export. All the commercial varieties are cultivars of *orientalis*, and the original blue and white colors have now been supplemented by a wide range of blues, lilac, purple, red and yellow. There are tall varieties with many more blooms, and double-petaled ones. However, after several years, this perennial will revert to simple blossoms and short spikes. Once primarily considered a potted houseplant, the hyacinth can now be found in any temperate garden, sometimes planted in masses, sometimes mixed with daffodils and tulips.

As a carving project, this can be a real challenge because of the multiple blooms and the necessity of obtaining a rounded effect to the flower cluster. It is advisable to set in at least ½ in., and possibly ¾ in., to provide plenty of clearance for carving and undercutting, because the long slender leaves appear in front of as well as behind the floral spike. Also, the six petals of each bloom curve and twist so as almost to form a mat. It is best to copy the design carefully and to begin modeling at the vertical center line and work outward, not concentrating on finishing one bloom until the adjacent ones are at least outlined. Each six-petaled floret must curve into its center and in again at petal ends. Leave the leaves until last because they pose no real problem. They are slender and hollowed and the upper ones can be undercut, but be careful to stabilize frequently and not to get any element too thin. The necessity of curving the floral mass will make undercutting practically unnecessary on the flower spike, because the rearmost petals may be depicted by incising the background a bit, although I curved mine down to it to suggest the continuing roundness. You can V-tool delicate lengthwise lines into each petal, as shown in the sketch, or simply leave tool marks showing, as I did.

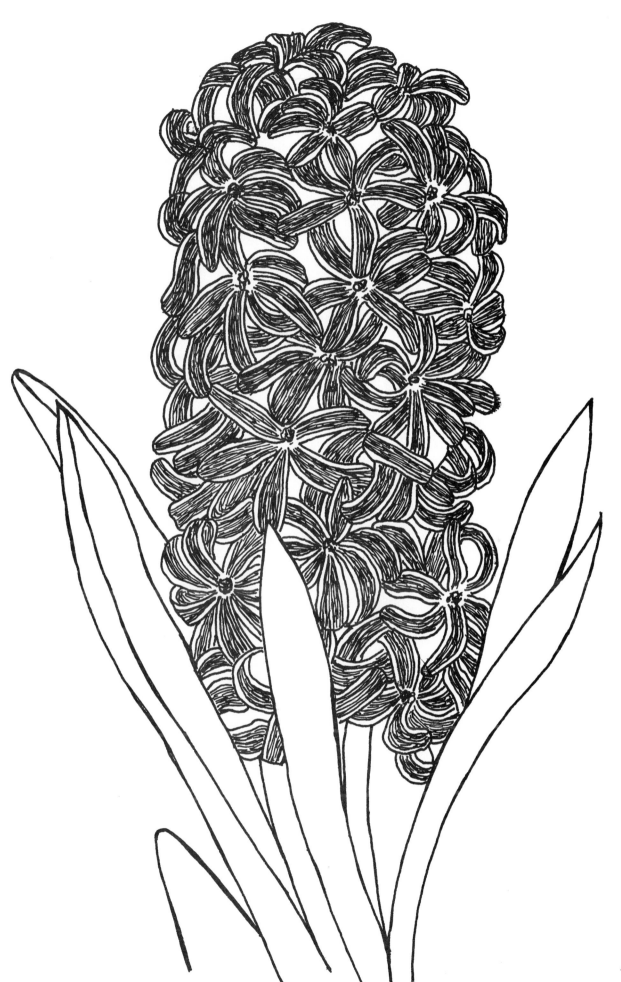

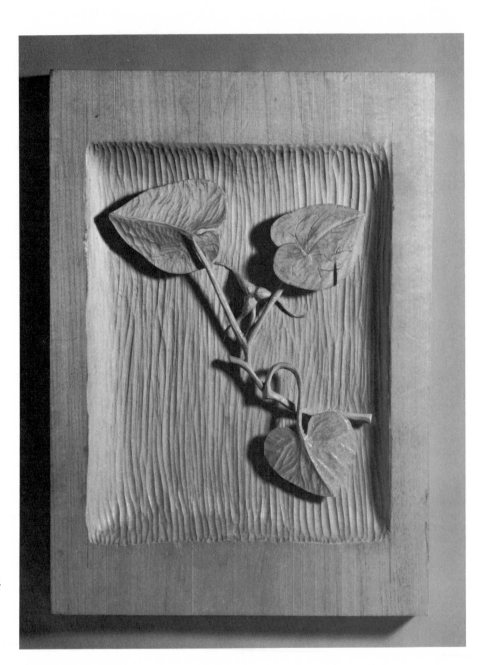

The Aromatic
Wild Ginger

*A more difficult project that
makes a beautiful carving.*

In deep, moist woods, the wild ginger (*Asarum caudatum*) blooms from April through July, depending upon altitude—but the bloom may be hard to see because it is often beneath fallen leaves, moss or mulch. Besides, it has no petals, but it does have a dark-red three-lobed calyx with long, attenuated lobes. The flower comes from the axil (joint) of the leafstalks. The plant grows close to the ground, spreading by sprawling rhizomes that usually grow through the mulch or leaves at the surface rather than through the ground, so it is almost a ground vine. The leaves are shiny green above, reddish beneath, and petioled (with leafstalks). The whole plant is permeated with a warm, pleasant, gingerlike aroma, and its volatile oil was once said to be used in perfume manufacture.

This particular pattern has several complications, all to do with the leafstalks. As you can see, they pass over the flower lobes and one curls upward to loop down to the bottom leaf. This means that ⅛-in.-diameter sections of stock must be cut free of the background and makes essential constant stabilizing and very, very careful carving with sharp small tools and a knife. This design is a real challenge to the skilled carver, but becomes a beautiful plaque when finished.

Designs such as this may end up with several deeply undercut areas which could be so fragile as to be troublesome. When I detect such a possibility, I reinforce the underside of the undercut area by spreading on it a thin layer of glue—either Elmer's Carpenter Glue or Franklin Tite Bond (I prefer the latter). If done carefully, this will not show and will reinforce weak and thin areas or sections, particularly those that are carved across grain.

46

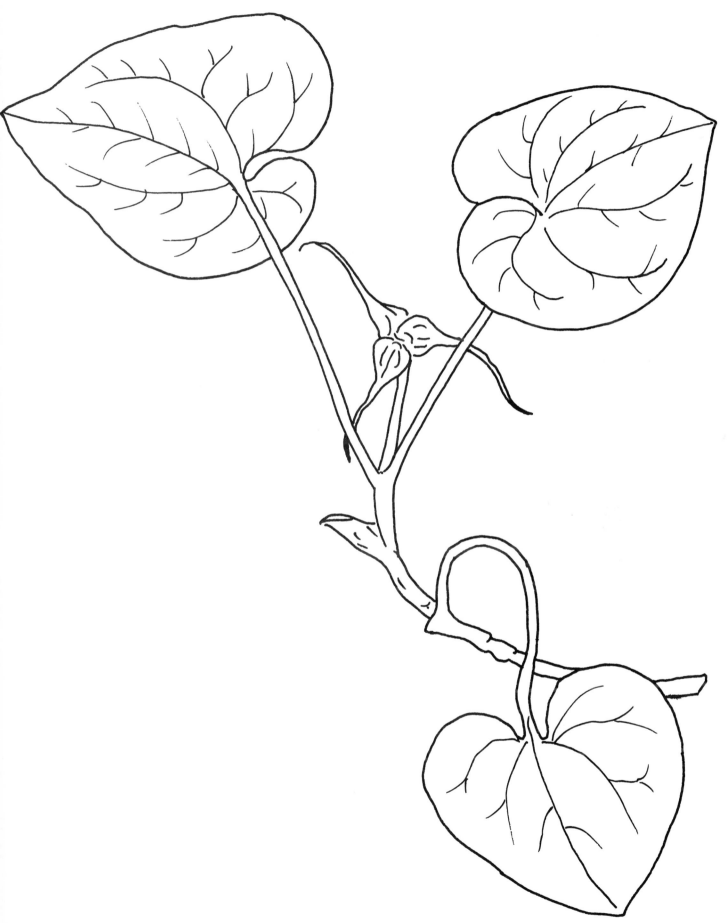

BIBLIOGRAPHICAL NOTE

Four of these 21 designs are adapted from *Wild Flowers of the Pacific Coast*, by Leslie L. Haskin (Binfords & Mort, Portland, Ore., 1934). These include the wild ginger, bunchberry, camas and blue violet. Other sources of patterns include *Garden Flowers in Color* by Daniel J. Foley (Macmillan, N.Y., 1943), *Flowering House Plants* by James Underwood Crockett and the Editors of Time-Life Books (Time-Life Books, Alexandria, Va., 1972) and *Flowers of the World* by Frances Perry (Bonanza Books, N.Y., 1972). There are a number of additional books, including children's coloring books, that may provide drawings—including one of that particular flower *you* want—suitable for conversion into carving patterns.